Volume 1

A collection of comic strips from **Juniper Crescent** And **The Sapphire Claw** by Steve Ince

A Steve Ince book

First published in 2004

Copyright © 2004 Steve Ince

The right of Steve Ince to be identified
as author of this work has been asserted.

All rights reserved.
No part of this publication may be reproduced, stored in a retrieval system, or transmitted, in any form or by any other means without the prior permission in writing of the publisher, nor be otherwise circulated in any form of binding or cover other than that in which it is published and without a similar condition being imposed on the subsequent purchaser.

Printed and bound by Global Book Publisher.

ISBN (to be filled in)

To June

For the greatest love
- the best support a creator could ask for.

Introduction

I've always had a love of comics and often used to draw my own in my teen years. Mostly they were my own versions of established comics doing the rounds in the early 1970s. It wasn't until my own children came along that I considered the creation of actual comic strips, newspaper-style. Not that they have been the direct inspiration behind the strips, rather that having children gave me a different perspective on life that enabled me to form the mind-set that gave birth to the type of strips I create.

My first strip, Toby, ran for six months in my local paper of the time, The Hull Daily Mail. It was shortly after this finished that I came up with the character Scout the One-Eyed Cat when walking down the street one day. Perched upon a wall down the street was an old, grey cat with only one eye and I immediately thought that a one-eyed cat would make a great comic strip character. By the time I reached home Scout had been born and everything else followed.

Juniper Crescent has been appearing on the web for well over two years at the time of writing.

- Steve Ince, November 2003. www.juniper-crescent.co.uk

Acknowledgements

Shaun, David and Jason, Emma and Caitlin - for keeping me real.
Charles, Tony, Dave and Noirin - for allowing me the chance to exercise my creative muscle in the field of video games at Revolution Software.
David Gallaher, Wendi Strang-Frost, Sean Frost, Steve Hogan, Simon Bowland, Julian Eales, Selina Lock, Arvid Nelson, EricJ, Justin, Steven Withrow, Patrick Coyle, Randy Sluganski, Marek Bronstring, Regie Rigby, Roberto Corona, Don Blackwell, Eoghan Cahill, Neil Richards, Jane, Danielle Corsetto, Simon Ecob, Eve Webber, Tim O'Shea, Doug Smith, Jessica Rydill and the members of the mailing list - for inspiration, support and positive feedback.

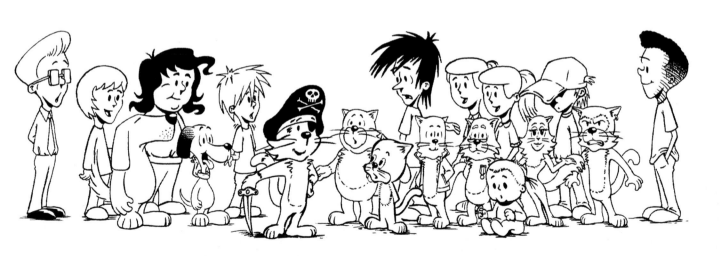

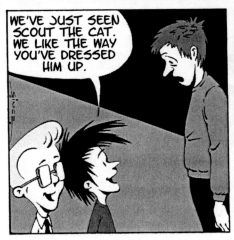
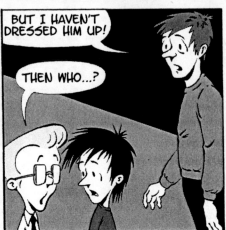
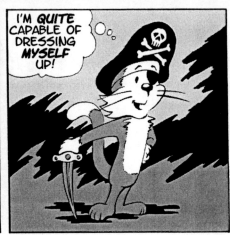
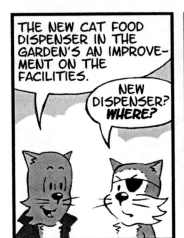
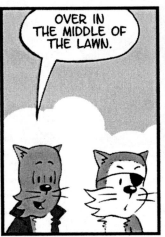
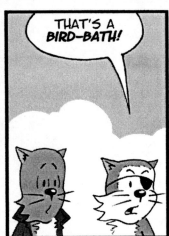
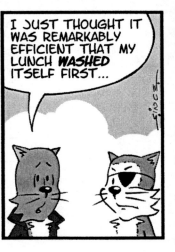

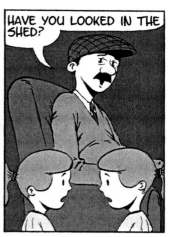

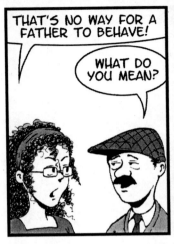
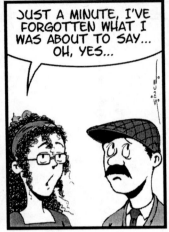
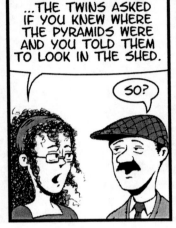
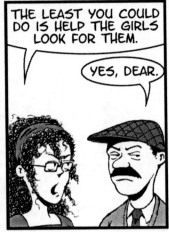
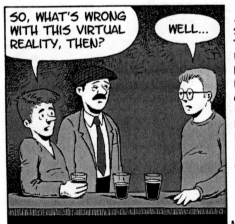
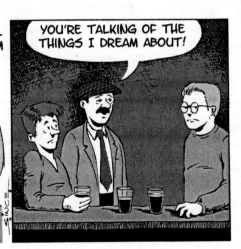

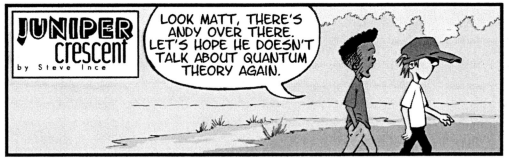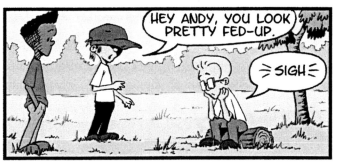

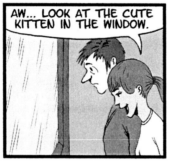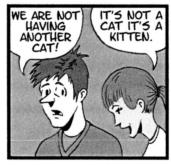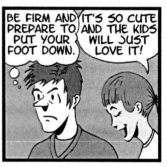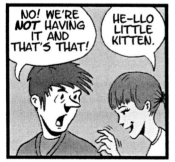

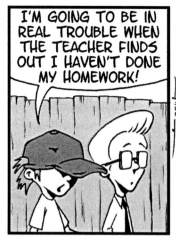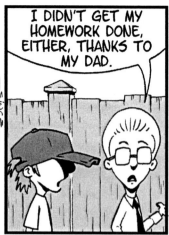

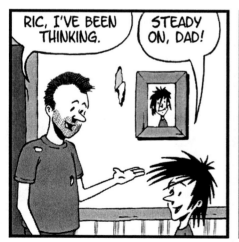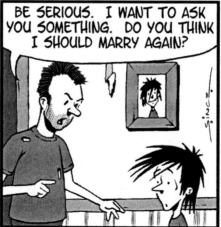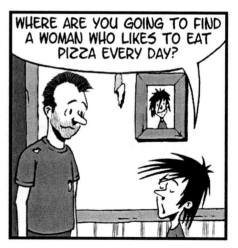

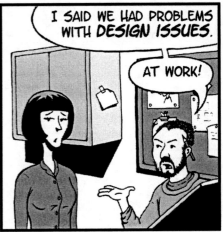

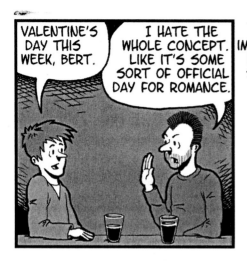

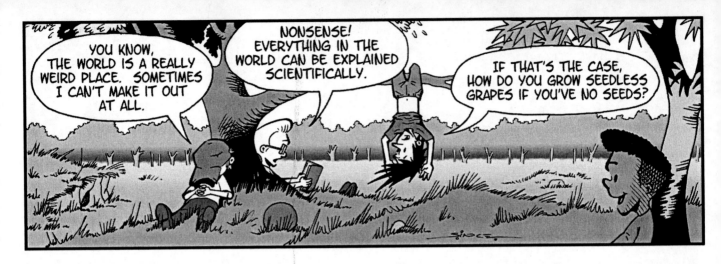
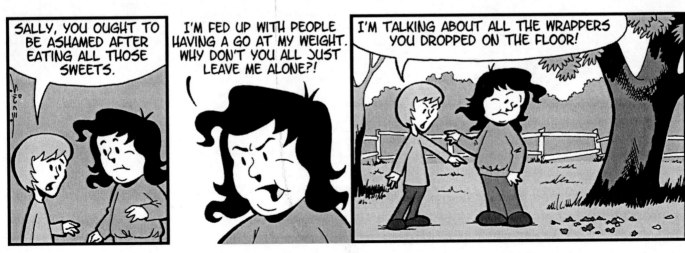

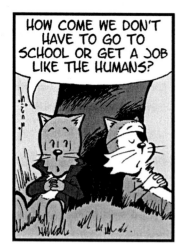

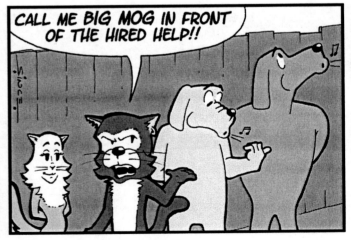

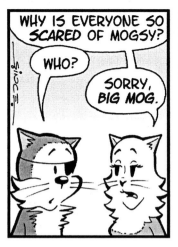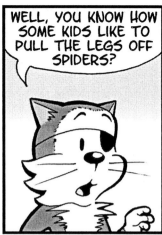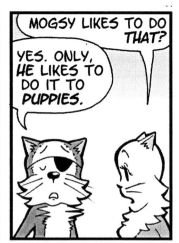

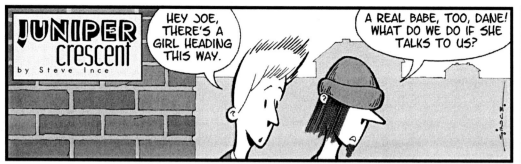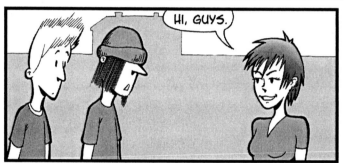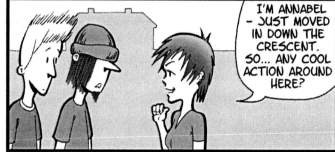

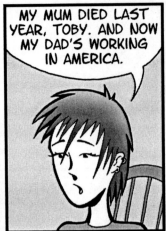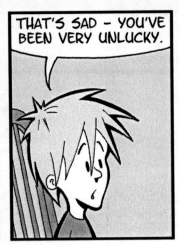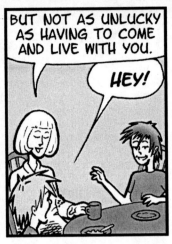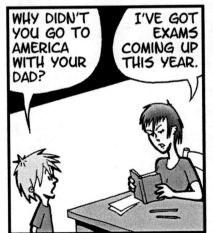

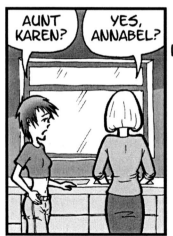

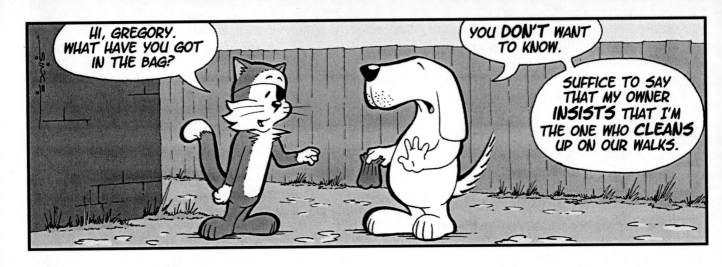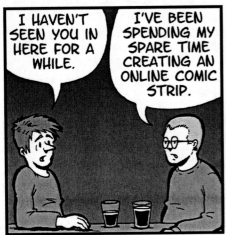

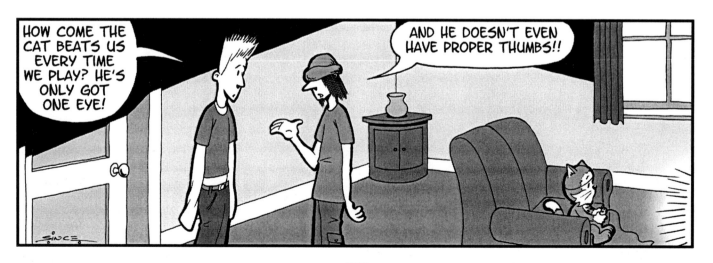

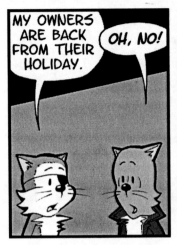
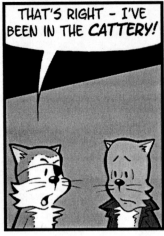

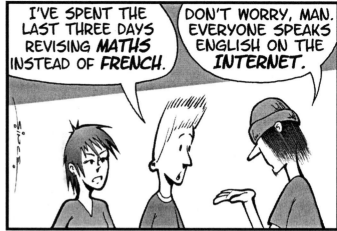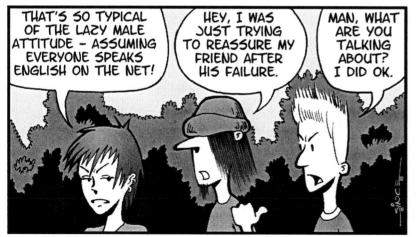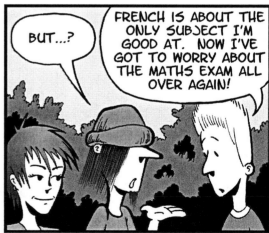

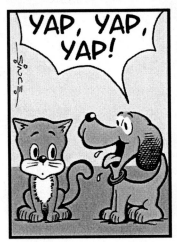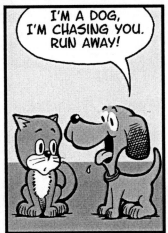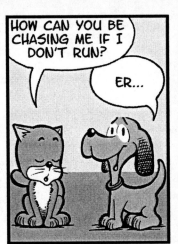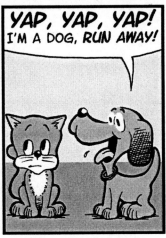

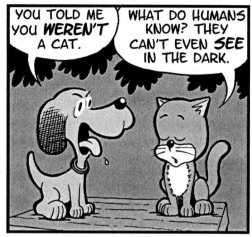
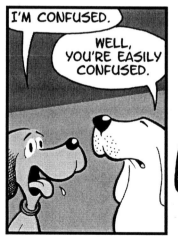
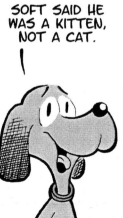
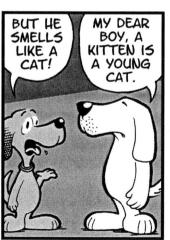

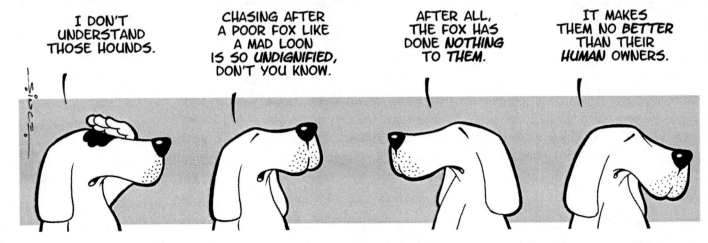

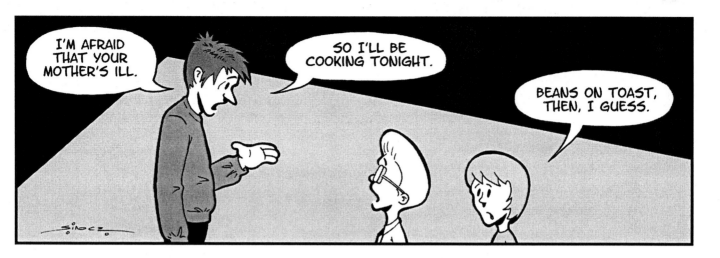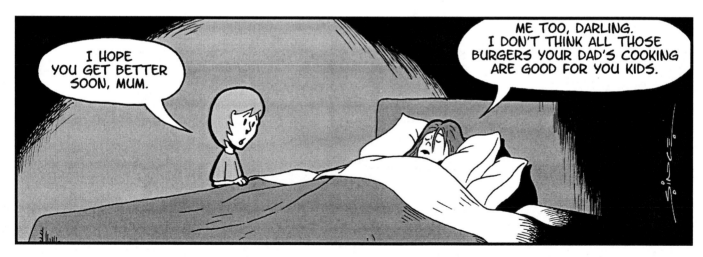

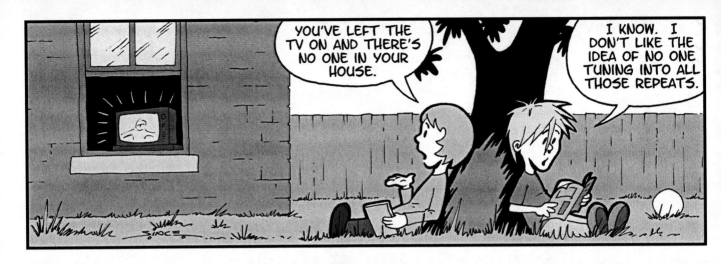

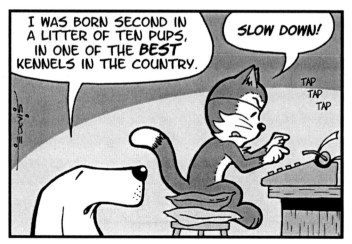
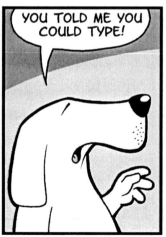
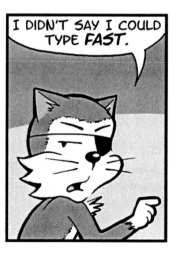

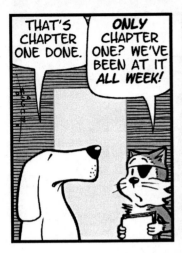

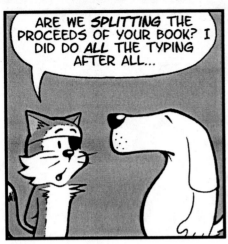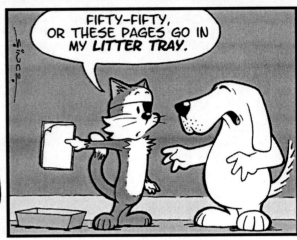

MOGSY, YOU SAID WE WERE GOING TO HAVE A *ROMANTIC* EVENING TOGETHER.

I BRING YOU TO SEE THE PLACE I GREW UP AND YOU SAY IT'S **NOT** ROMANTIC! WHAT **MORE** DO YOU WANT, MIMI?

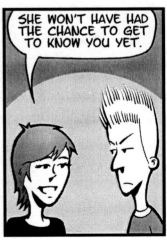

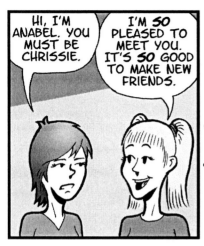

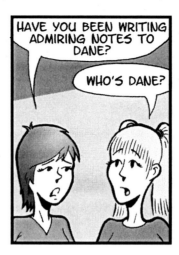
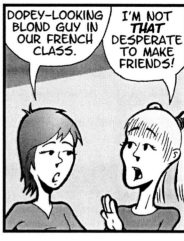
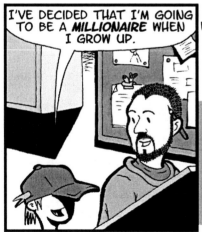

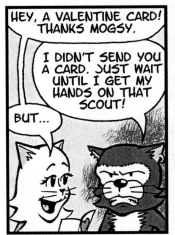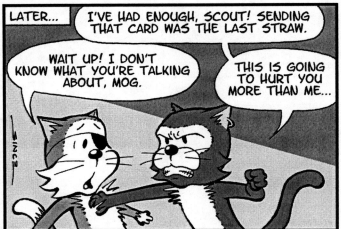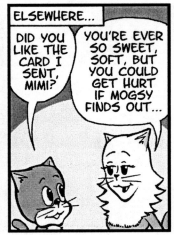

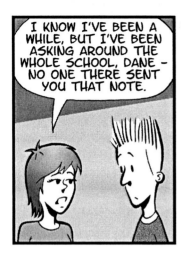

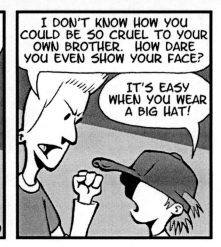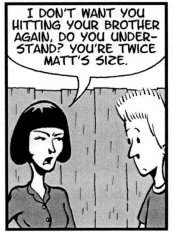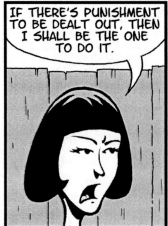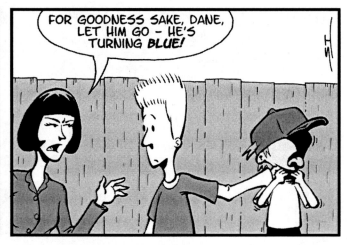

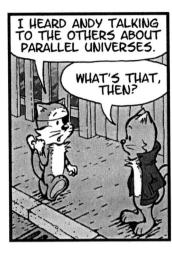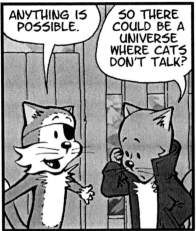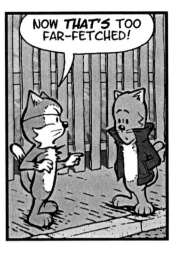

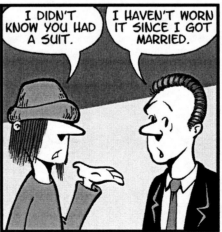
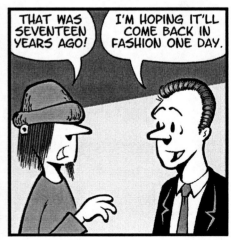

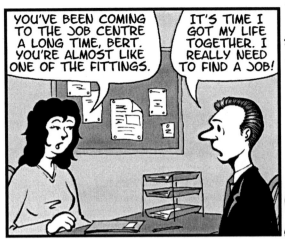

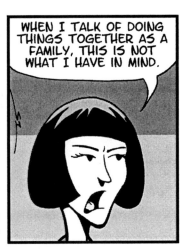

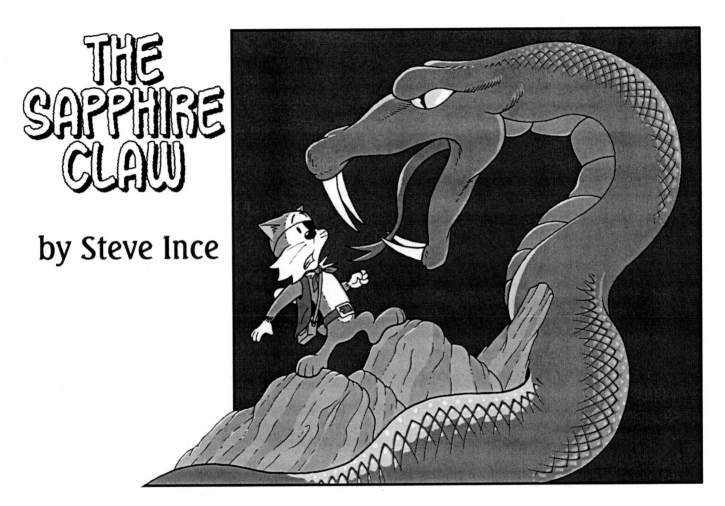

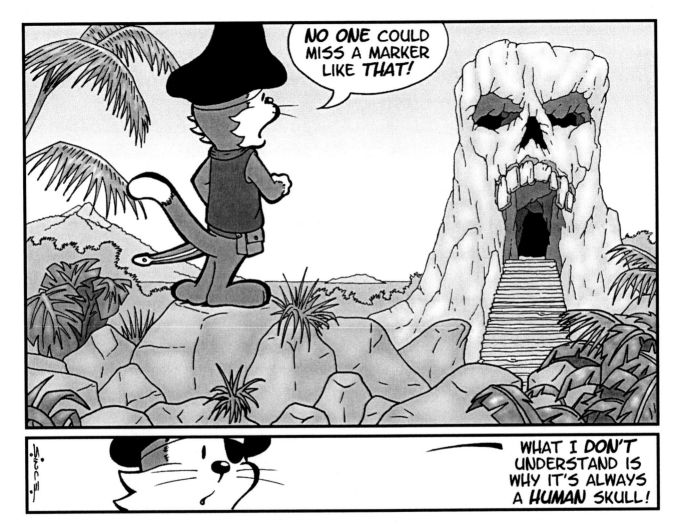

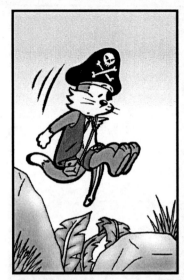

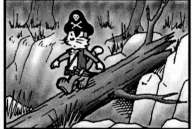

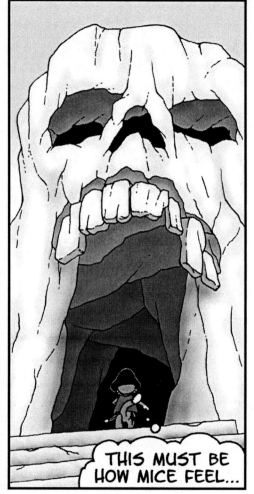

THIS MUST BE HOW MICE FEEL...

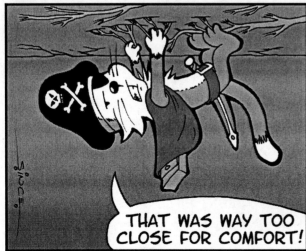

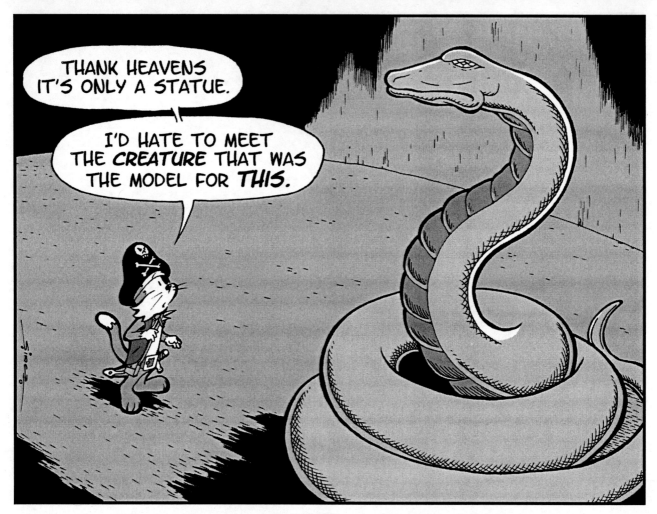

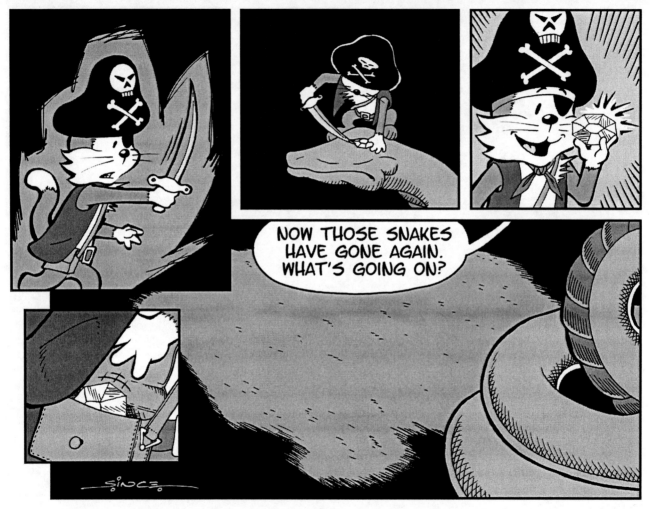

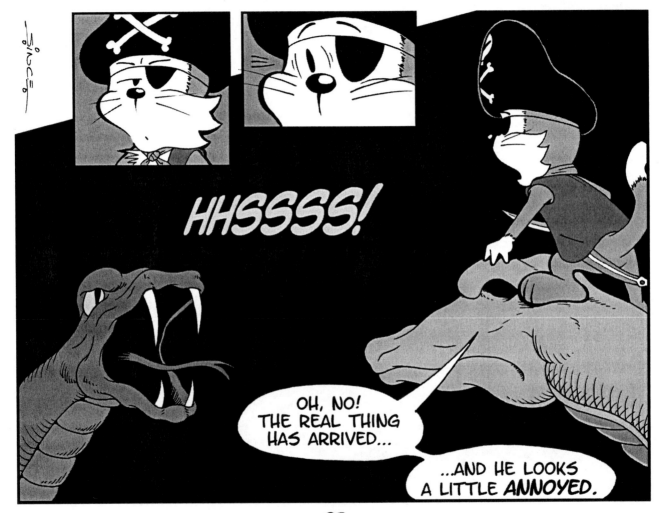

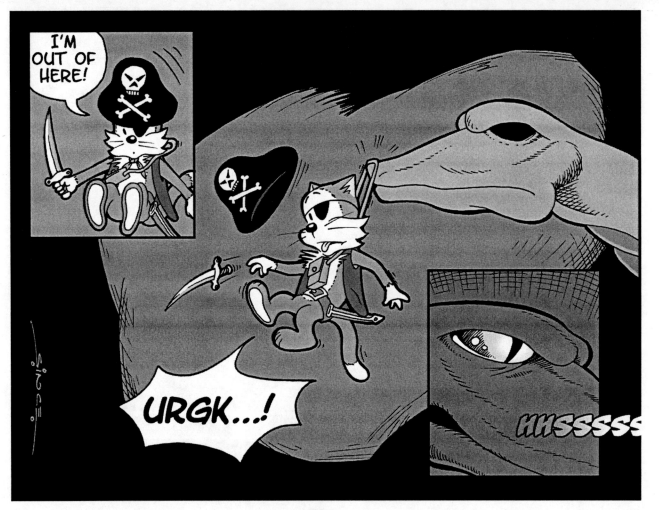

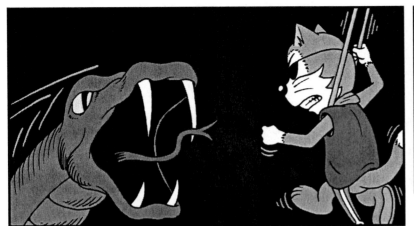

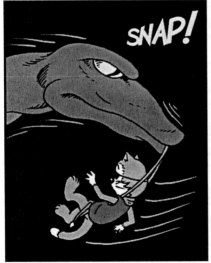
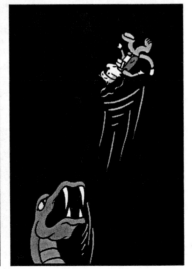
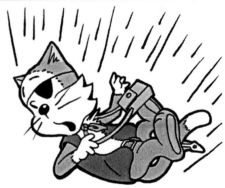

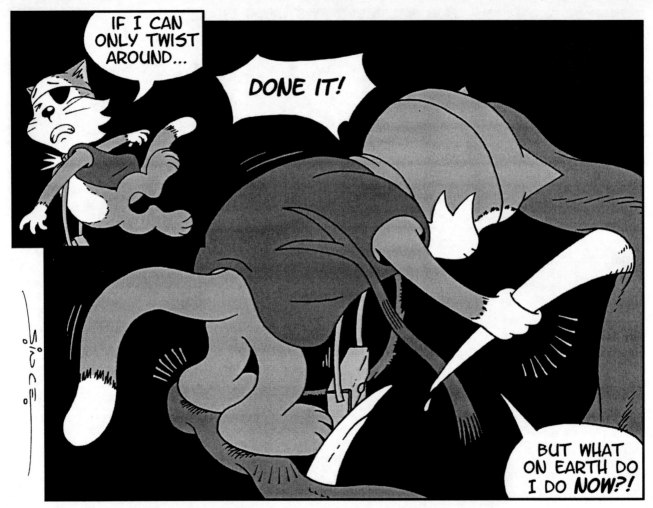

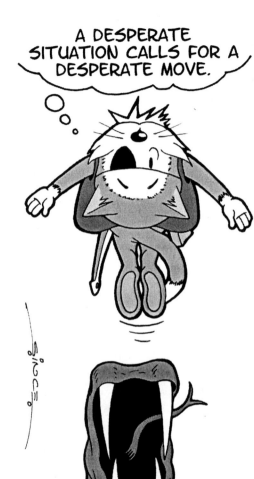

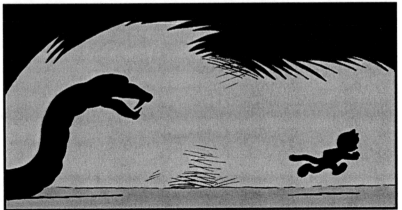

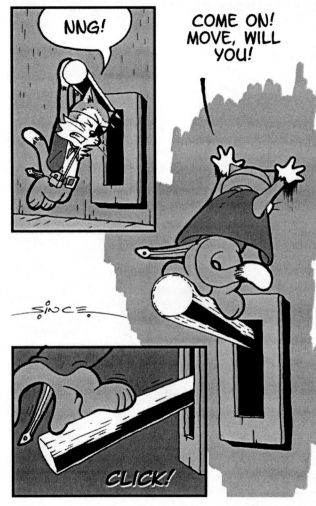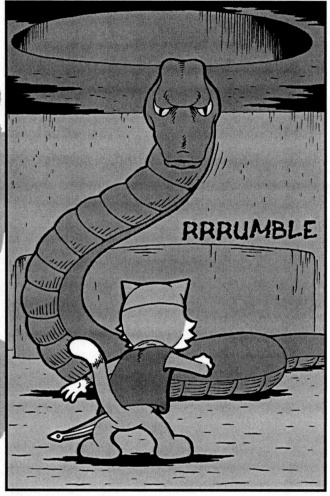

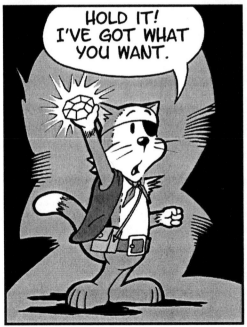
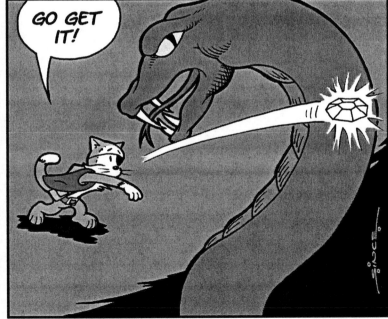

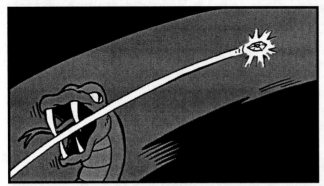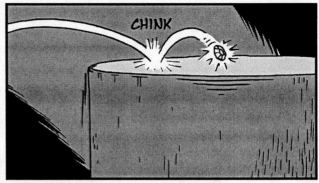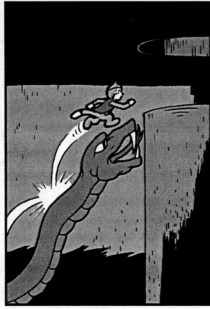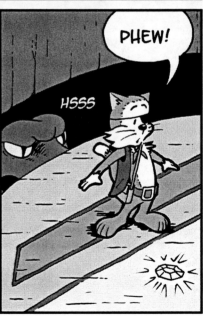

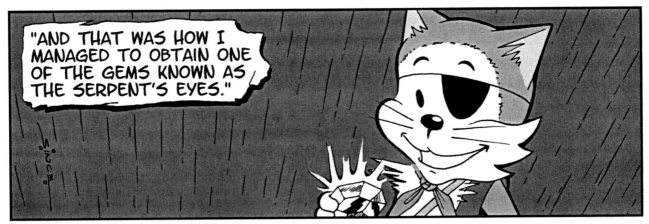
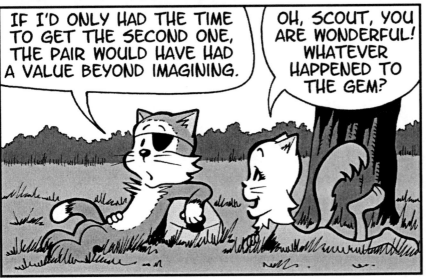

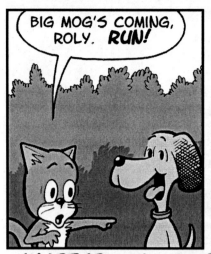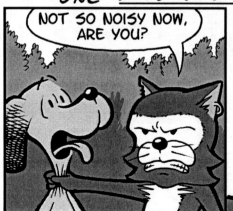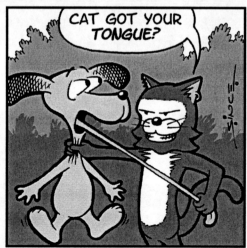

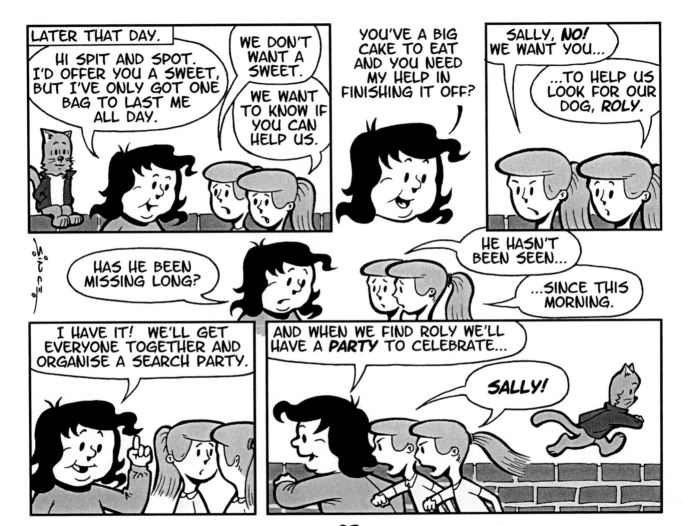

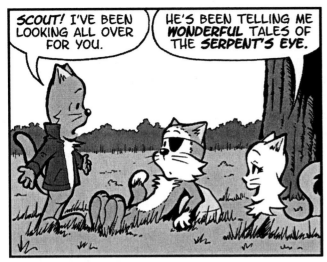

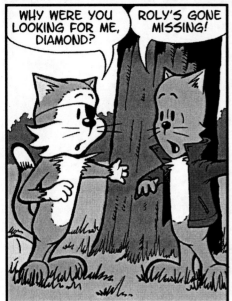

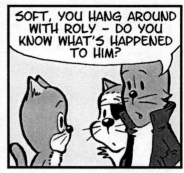
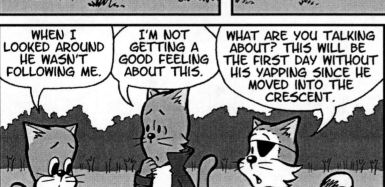

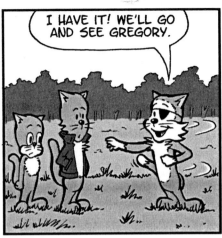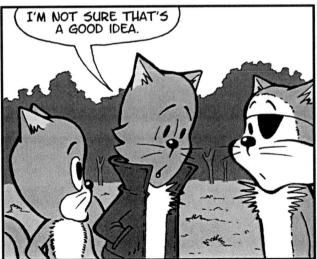

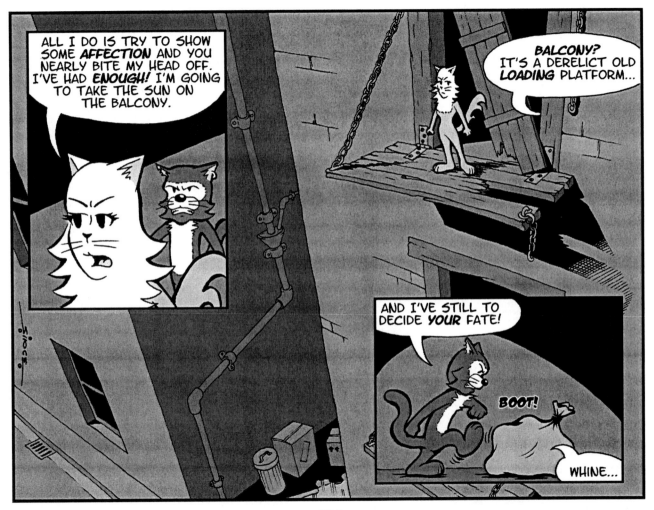

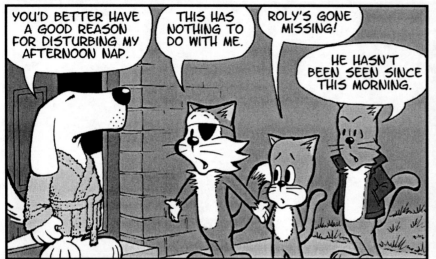

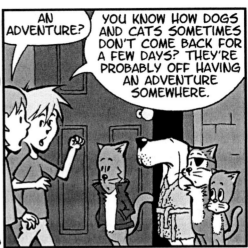
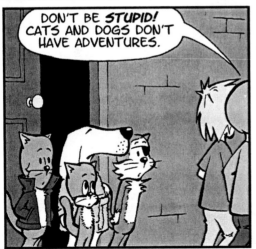
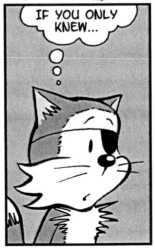
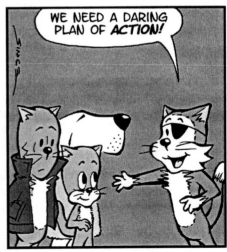

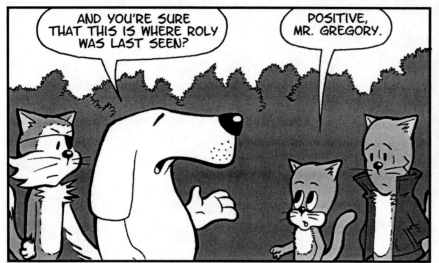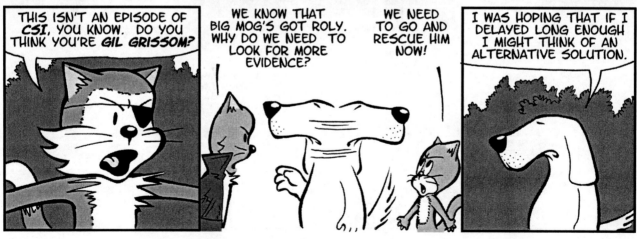

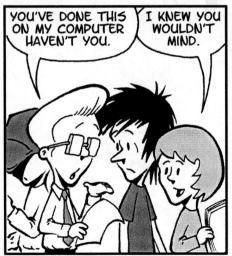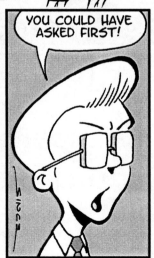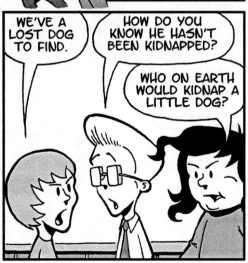

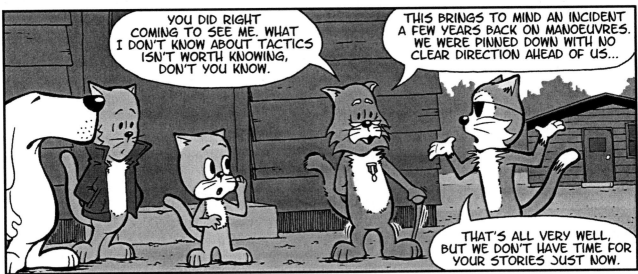

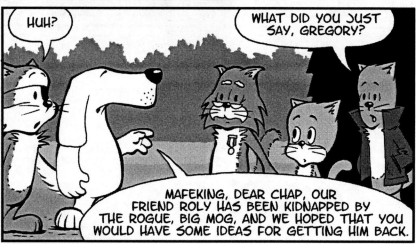

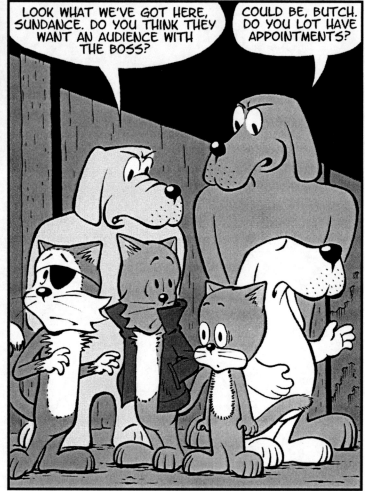

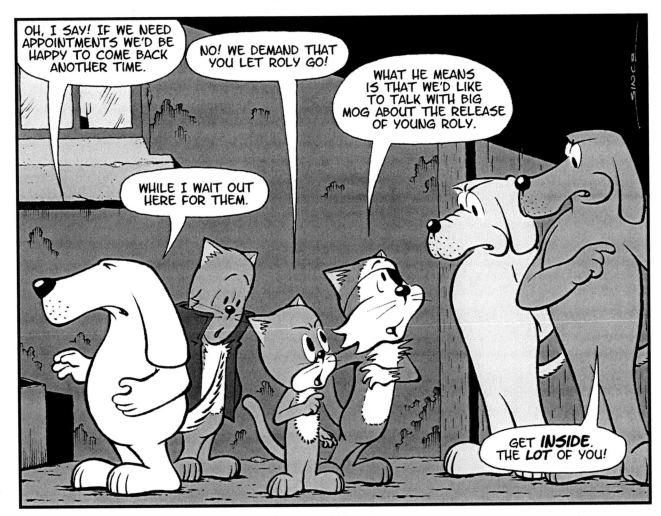

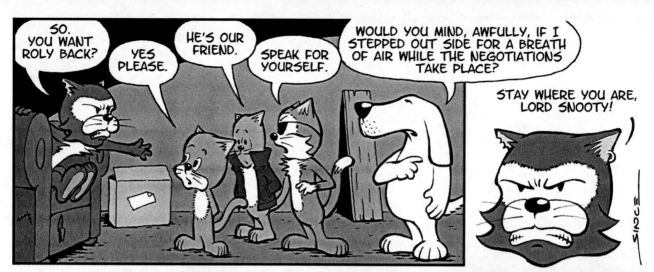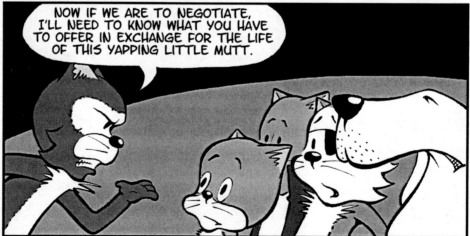

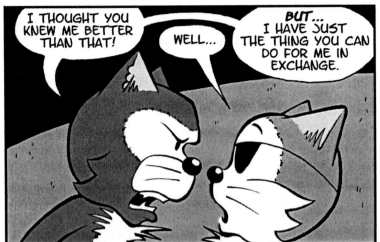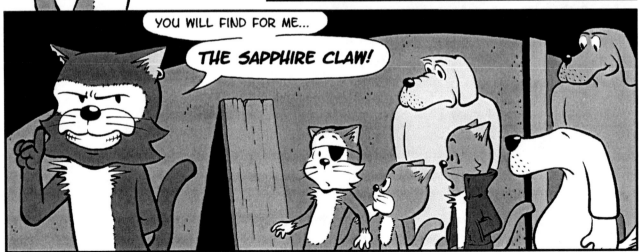

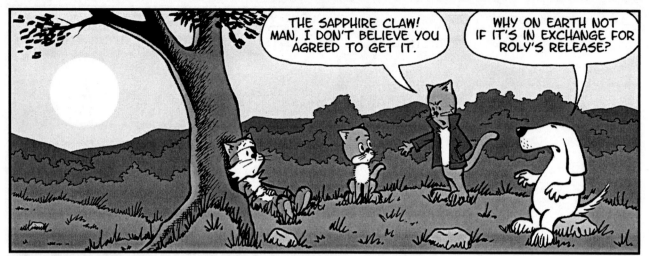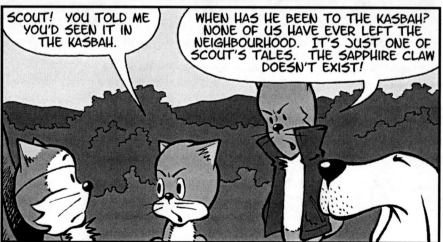

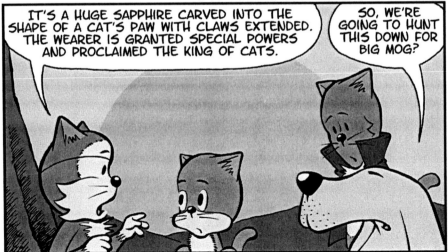

TO BE CONTINUED